DOG SAVE
THE
QUEEN

The Tails of Britain
Words and Pictures by Jeff Selis

CHRONICLE BOOKS
SAN FRANCISCO

Library of Congress Cataloging-in-Publication Data:

Selis, Jeff.
Dog save the queen : the tails of Britain / words and pictures by
Jeff Selis.
p. cm.

ISBN 0-8118-3925-7

1. Dogs—Great Britain—Anecdotes.
2. Dogs—Great Britain Pictorial works.
3. Photography of dogs—Great Britain. I. Title.

SF426.2.S462 2003
636.7'00941—dc21
2003006537

Manufactured in China

Book Design by Peter Antonelli

Distributed in Canada by Raincoast Books
9050 Shaughnessy Street
Vancouver, British Columbia V6P 6E5

10 9 8 7 6 5 4 3 2 1

Chronicle Books LLC
85 Second Street
San Francisco, California 94105

www.chroniclebooks.com

This book is dedicated to Elizabeth Hawthorne Hunt, the queen of so many hearts, including mine. Thank you for designing the first two books, Hawthorne. You may be gone now, but I felt your presence all the way through this one, too. I love you.
—Jeff

INTRODUCTION

Why *Dog Save the Queen*?

For me, this book was the logical next step in my grand plan to see the world reflected in the eyes of the dog. My first book, *Cat Spelled Backwards Doesn't Spell God*, I did in my own backyard of Portland, Oregon. It was born out of deep love and appreciation for all dogs. It was the perfect way for me to combine my passions for photography, writing, and the four-legged wonders themselves. The book was successful enough to gain me the opportunity to do another book, *Dog Bless America: Tails from the Road*, which added one more of my passions to the mix—travel. It had been a longtime desire of mine to discover America—I just never dreamed I would get to discover it with a book deal, a camera, and my faithful dog, Otis, in tow. As a result of my experience, I have since taken a more doglike approach to life. No, I don't lick myself in those particular places, but I do tend to find more joy in the simple things— things like digging in the garden, lying on the heater vent, and staring at someone long enough that they finally give me what I want. More important, my journey around America allowed me to share with readers three very important discoveries: Home is definitely where the heart is, the world is far too cool to justify staying home for too long, and dogs' contributions to the world are universal and should be celebrated as such.

After a little scratching behind the ear, I realized that the next step was Great Britain. Everyone knows that the British are stark raving bonkers for their dogs. The queen herself has had an ongoing love affair with the dog ever since she first put on her crown more than fifty years ago: She has opened her gates and her heart to more than thirty corgis during her reign, and she even introduced a new breed—the dorgi—when she mated one of her dogs with Princess Margaret's dachshund.

Although I attempted to obtain an audience with the queen (Her Majesty, unfortunately, was a wee bit busy tending to her commonwealth), I know that these books are not dependent on any one particular dog—nor are they about status or class, for sure. Certainly, I would have been ecstatic to meet one of the royal dogs, but the dogs in these pages are celebrated for what they stand for as a whole. To a dog, it doesn't matter if it's sleeping on gold-studded pillows inside an ancient castle or sleeping in a doorway with its human on the streets. To a dog, we humans are all kings and queens— hopefully, more deserving than not!

So, off I went. When I arrived in Britain, I was struck by the sheer number of dogs. They were everywhere. It seemed almost as if *they* ruled. They patrolled grocery stores. They rode in taxis. They took the Underground. They had their own waste bins in the parks. They hung out in pubs till last call. They even drank beer and celebrated when England scored a one-nil victory over Argentina in the World Cup! More important, though, when mighty England fell to the Brazilians in the quarterfinals, it was these same dogs that soaked up the tears of a nation, thus demonstrating one more truth: It really doesn't matter whether you win or lose, it truly is *how* you play the game. And it was plain to see that dogs are playing it fair and square on both sides of the Pond.

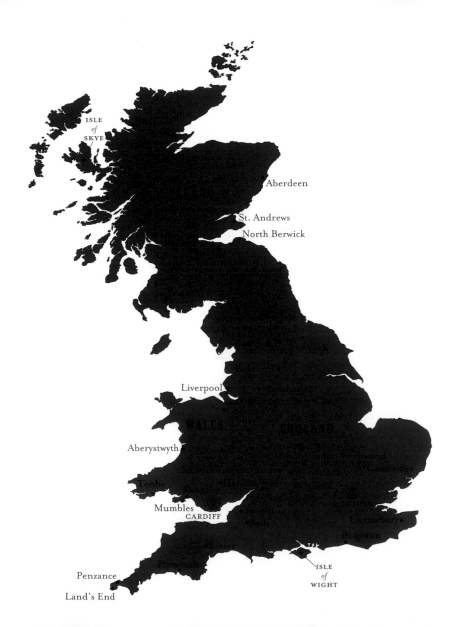

SOUTHEAST ENGLAND
London
Brighton
Isle of Wight
Canterbury
Cambridge
Woodstock
Oxford

SOUTHWEST ENGLAND
Bristol
Bath
Exeter
Plymouth
Penzance
Land's End

WALES
Aberystwyth
Hay-on-Wye
Cardiff
Swansea
Mumbles
Tenby

HEART OF ENGLAND
Milton-under-Wychwood
Stratford-upon-Avon
Chester

NORTH COUNTRY
Liverpool
York
Bradford
Keswick
Carlisle
Manchester

SCOTLAND
Dumfries
Edinburgh
North Berwick
Glasgow
Stirling
Perth
St. Andrews
Aberdeen
Inverness
Ullapool
Loch Ness
Isle of Skye

SOUTHEAST ENGLAND

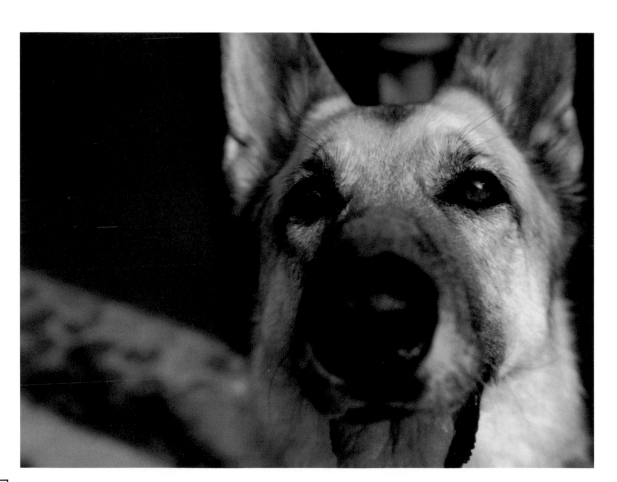

billie
a.k.a. Billie Girl

Billie Girl's dad was a champion and her mum was a beautiful blonde, which explains why this purebred German shepherd is so well mannered and good looking. She adores cappuccinos and thinks yogurt is the nectar of the gods.

One may think Billie a bit high-falutin, but her favorite days are the ones spent lying on the floor of her local pub in South Kensington. She doesn't smoke, but she thanks the heavens above when presented with an ashtray full of Guinness froth.

muffin

According to her human, Muffin is an aspiring supermodel from Notting Hill. She's definitely got the looks, and her figure should stay true to form, because she'd rather swim one hundred laps than eat a plateful of bangers and mash. A jolly good dog, Muffin has a royal blast marking the grounds of Kensington Gardens.

Her best friend is a cat named Misty.

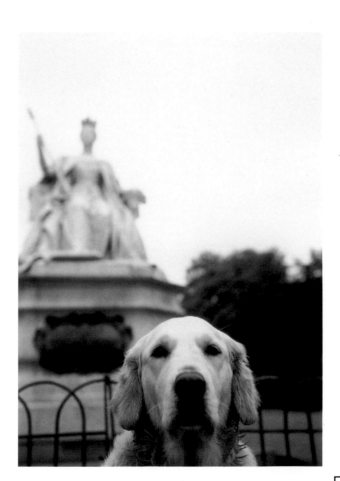

hugo

Hugo is the boss. Well, that is, unless he is dealing with flies or bumblebees. Hugo was stung during his days as a curious young Petite Basset Griffon Vendeen (a fancy moniker for the French basset hound). Since then, he has had serious issues with all insects, usually opting to hightail it when confronted.

That's where intimidation ends. His current love interest is a Great Dane, an enormous gal five or six times his size, but he's got her wrapped around his paw. Word has it that a typical date means taking her out for a few drinks of dirty water. Most gals would object, but, after all, Hugo *is* the boss.

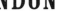

georgie

Georgie is a blue-merle Border collie with a penchant for balls and squeaky toys. She'll fetch all day if she's got a willing partner to hurl an object again and again.

Georgie's a herding dog by trade, and her only motionless state is that of sleep. Georgie stopped moving just long enough for this photo op along the Princess Diana Memorial Walk.

Cheers, Georgie!

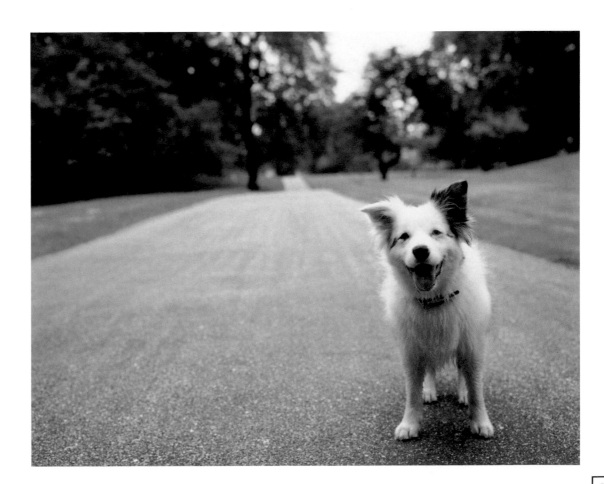

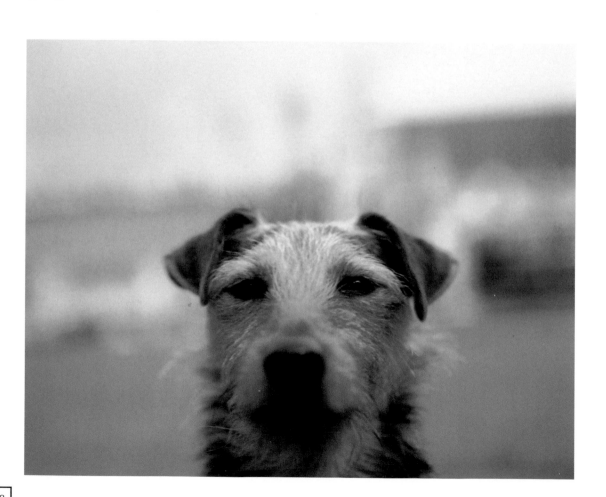

finnegan

Finnegan spends most of his time chasing pigeons. And swans. And cats. Just for fun, of course. In fact, a very funny sight is the confused state that overcomes Finnegan when a cat doesn't run away.

Finnegan is extremely curious and outspoken. And he always takes the initiative. For example, if he wants to play, he will simply place a ball in his human's hand. He eats like a horse, but he stays skinny because of constant activity. He lives for his walks. Parents, beware! Finnegan has a tendency to jump into baby prams. Remember, he's curious.

One more thing—he will pee on his master's leg if there is nowhere else to go.

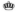 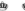 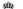
bonnie

Q: What do Big Ben and little Bonnie have in common?

A: They both always have the time.

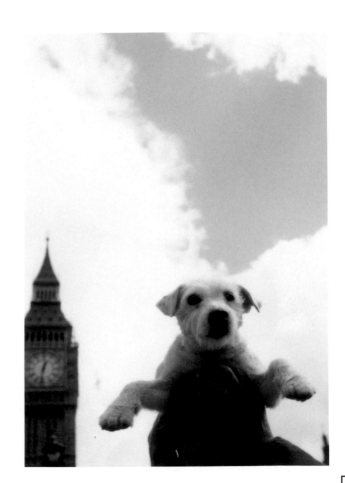

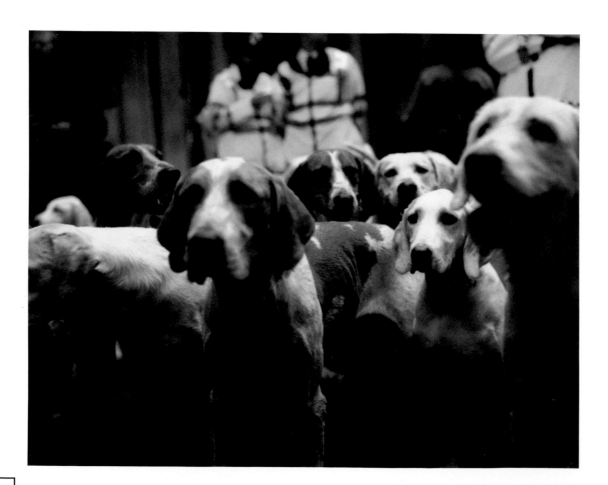

foxhounds

Today I happened upon a pro–fox hunting rally near Parliament Square, filled with marchers and police officers and foxhounds and horses. The foxhounds I interviewed all seemed a bit anxious about their fate as debate raged over whether the fox should be given immunity through banning the sport. As I was snapping away with my camera, a beautiful huntress asked me my name from atop her horse.

>>>

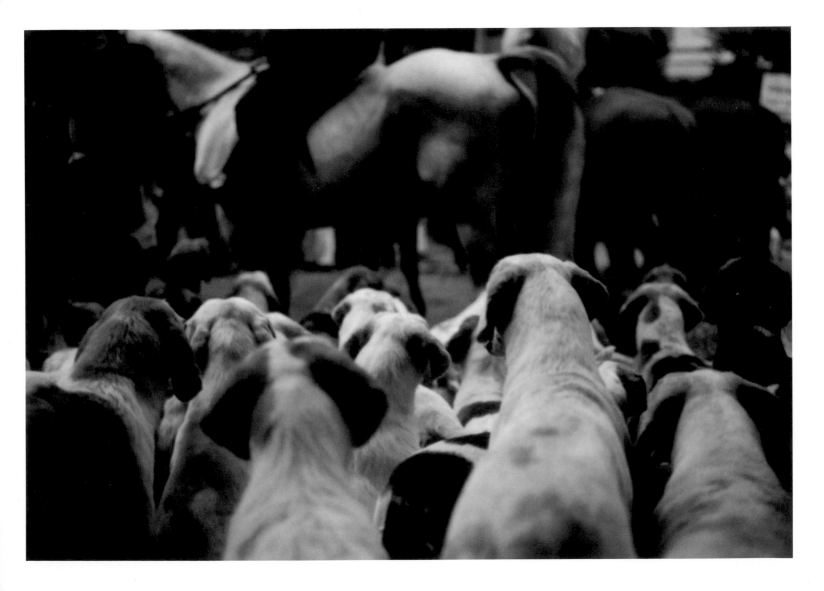

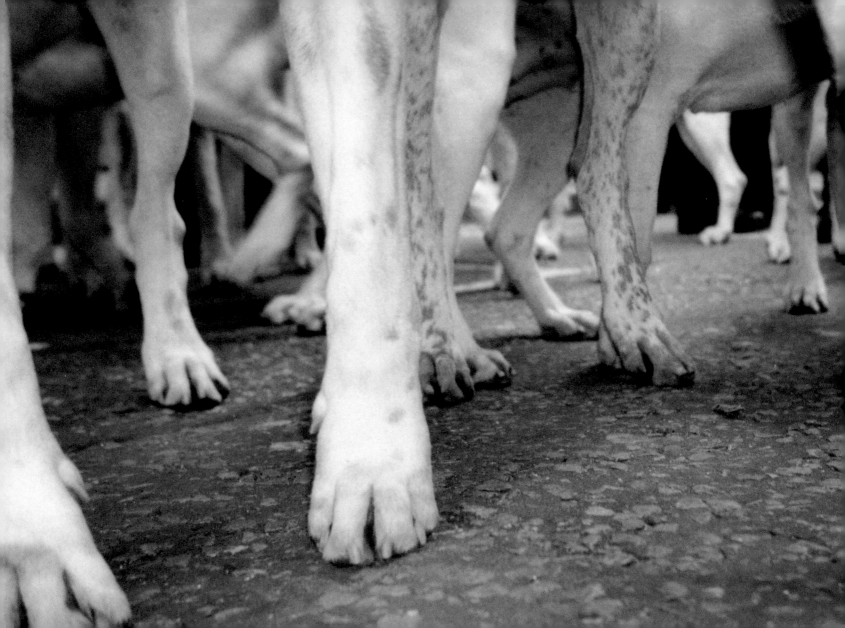

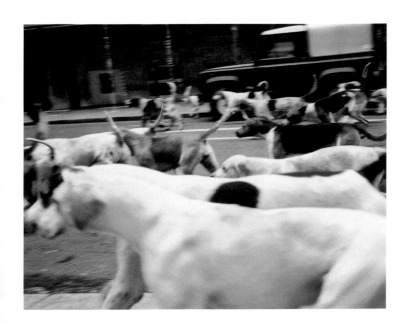 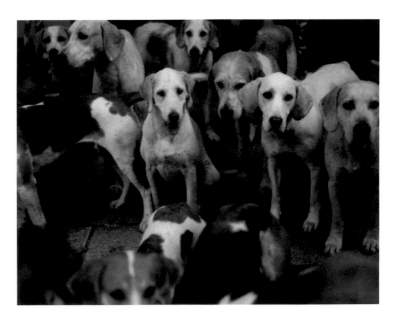

Next thing I knew, she was off to the races, and all the hounds were gone. Mayhem ensued. Bobbies blew their whistles. "Impasse! Impasse!" they screamed. The huntress had led my one hundred or so photographic subjects into the busy streets of London.

Traffic stood still. The hounds were having their say. The fox was unavailable for comment.

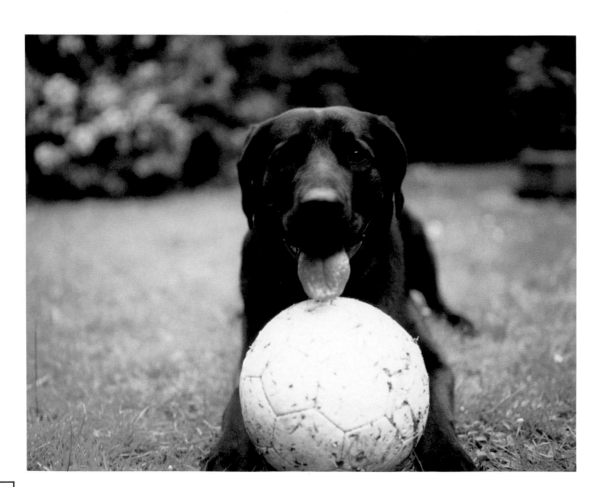

lolo

Lolo loves kicking it at Hampstead Heath. In a country where football (that's soccer to Americans) means as much as the air you breathe, Lolo's passion is unequaled.

Unfortunately for him, however, he has to stay on leash watching from the side of the pitch. As a matter of fact, if it weren't for the leash, Lolo would be dominating the match without even breaking a sweat. He may not bend it like Beckham, but he can wear out any defender with his uncanny ability to control the ball.

And Lolo will never receive a yellow card for bad breath. He loves toothpaste.

racing greyhounds

They can run like the wind, but one has to ask: Are they racing for the rabbit, or are they racing for their lives? As long as dog racing is a reality, many greyhounds will be in need of homes. For those who might be interested, greyhounds are twice as nice as they are fast.

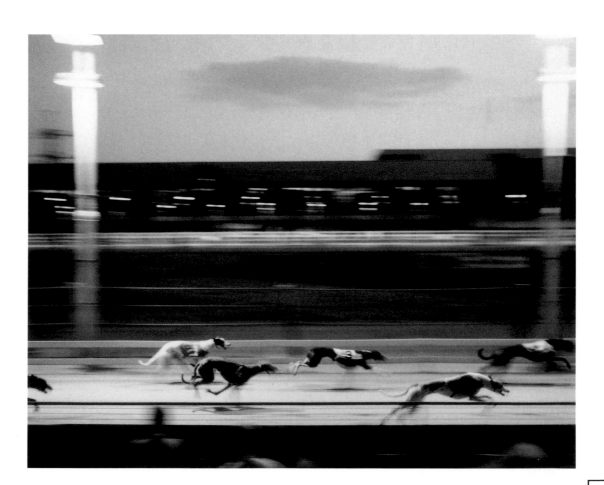

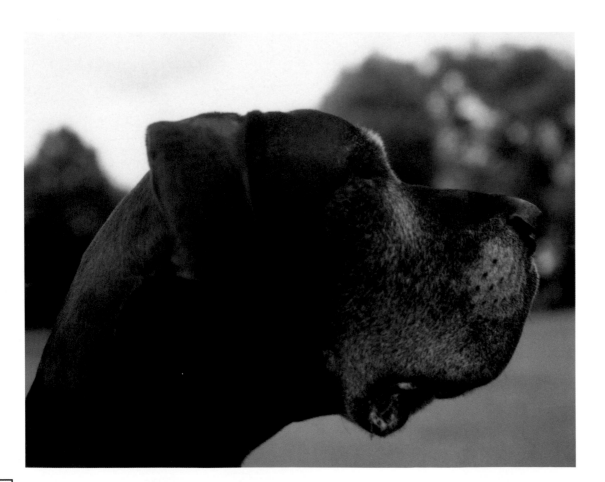

henry

Henry is a nervous boy. He was jumped by another dog as a young pup and has since been of a mind that all dogs are out to get him; therefore, he is always scanning, living his life on high-alert status.

Two activities that relieve his defensive posture are chasing flashlight beams and watching *Animal Planet* on TV, though he will attack the set if he sees a dog on it.

One dog Henry would never attack is Shenny, his adopted sister, who has somehow managed to dig out a place in his heart.

shenny

Shenny almost starved to death after being orphaned at an early age. She was taken in by the Battersea Dogs' Home—the U.K.'s largest canine shelter—and nursed back to health. She eventually found a family to provide her the perks of the good life—the main perk being food. Others include rolling side to side in the grass on a sunny day and lounging with her best chum, Henry (see previous page).

One habit she has been unable to break, however, is eating mud. See, it was mud that provided Shenny the minerals that kept her alive during her days as an unsheltered orphan.

Here's mud in your belly, Shenny.

rom

Rom loves to dig. According to his human, he's into landscape gardening from the roots up. His other passion is food: He will devour a honeydew melon like there is no tomorrow. If tomorrow comes, he'll hope for eggs and rice pudding. Just don't try slipping him any veggies—that's where he draws the line. Perhaps this is why Rom is so keen on digging up the garden: Carrots are the enemy!

dudley

Dudley comes from good genes: His mum won Best of Breed at Crufts. Still, Dudley arrived as the ugly duckling of his litter, with excess skin that made him look more like a shar-pei than a weimeraner, and eyes with a distinct Marty Feldman quality to them. Though Dudley might be proud of his mum, he prefers a life more ordinary. He'd rather spend his time gnawing on shoes.

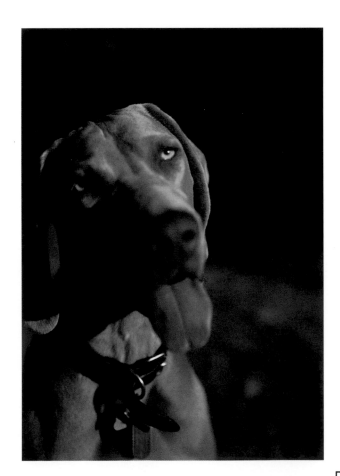

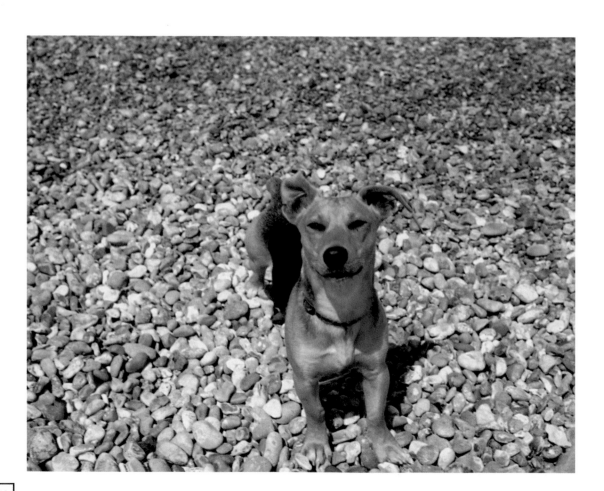

jack

Do you know Jack?

Jack is a Jack Russell terrier who won the lottery when he found a home near the rocky beaches of Brighton. See, Jack has a seriously warped obsession about rocks. *Warped.* He'll fetch 'em up twenty-four hours a day, not even stopping when he dreams. And, much like the rocks of Brighton, this dog's heart is solid to its core.

Now you know Jack.

tango

Tango's name seems a fitting one—he's always in step with you.

Tango was rescued from a bad home, one of ten dogs who were being neglected. Now he's an only child, and loving it. He was mildly irritated, though, when he was castrated the first day in his new digs. It's a high price to pay for a fella, but all indications show Tango to be quite pleased with the trade.

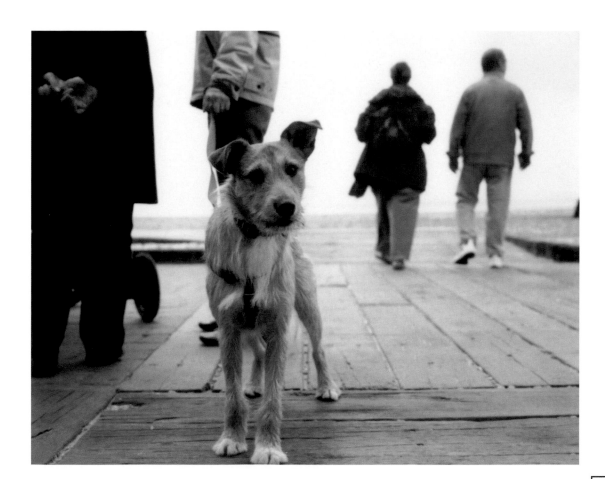

charlie

Charlie is an escapologist. Lock him up and throw away the key, and he'll still find a way out. One thing he'd never run away from, though, is the shores of his dear Isle of Wight. He can't get enough of romping along the beach.

Charlie is a Spinone Italiano, a rare breed with soulful, humanlike eyes. His favorite sight is a bin full of rubbish.

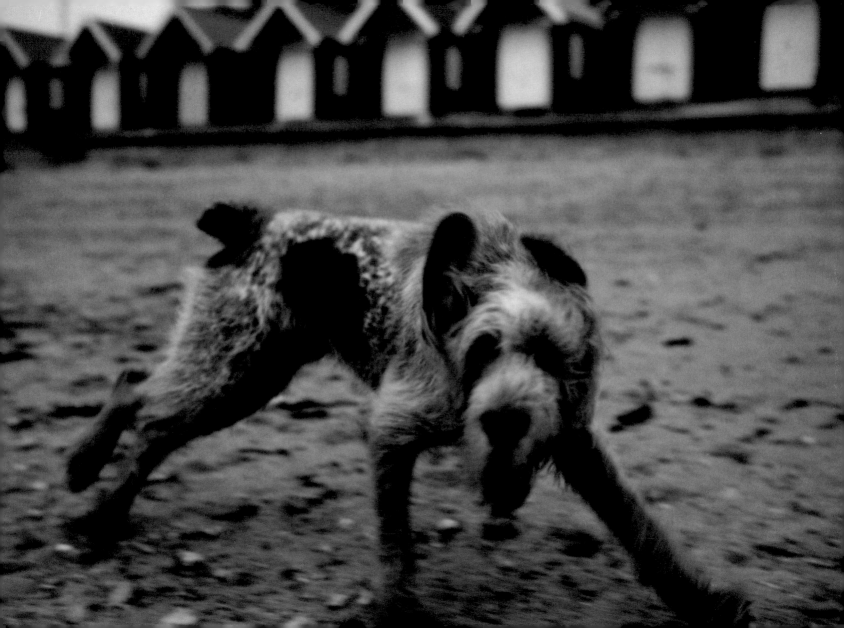

levy

From *Canterbury Tales* to Canterbury tails . . .

In 597, Pope Gregory I sent St. Augustine to reconvert the English to Christianity. Upon arrival, St. Augustine built a beautiful abbey, but, nearly a thousand years later, King Henry VIII came along and demolished it.

Humanity's loss is dogs' gain, at least in this case. Levy and his human live just a couple blocks away from the historic abbey grounds, entitling them to a residence pass. Lucky dog gets to visit twice a day.

When Levy's not roaming the grounds, he can usually be found snacking on something—he loves root vegetables, especially turnips, and has an affinity for chocolate and cheese.

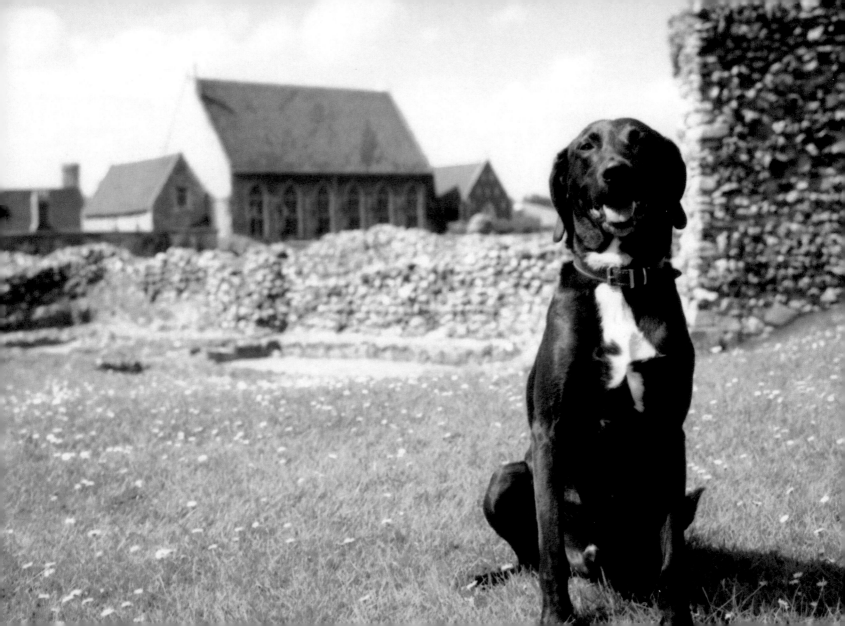

smart people live in cambridge.

Didn't see but one dog, though, which makes me wonder just how smart these people really are . . .

austin

Austin has the perfect job for a dog who loves walks: He's a guide dog. And, at eleven years of age, Austin is an old pro. It was once said that giving a blind person a guide dog is almost equal in many ways to granting that person sight.

Austin's human would concur, except for when Austin leads him into lampposts.

rosie

Rosie resides in the same town where the great Sir Winston Churchill was born. On the subject of unconditional love, Churchill once said, "Each beat guides me in your direction."

Seems they have yet another thing in common.

mendoza

Mendoza lives with his human
on the streets of Oxford, home
to one of the brainiest schools in
the world. It's fitting, then, that
Mendoza would live here,
because he is a very smart dog
himself. He can sit, lie down,
roll over, play dead, and more.
But what's even more impressive
about him are the things that
can't be taught, like cunning and
instinct. His human claims
Mendoza can smell danger when
it's still a block or two away.
"Dogs just know," he says.

It was another homeless man
who claimed that when dogs die,
they go to heaven and let God
know who is good and who is
bad. Think a Rhodes Scholar
could do that?

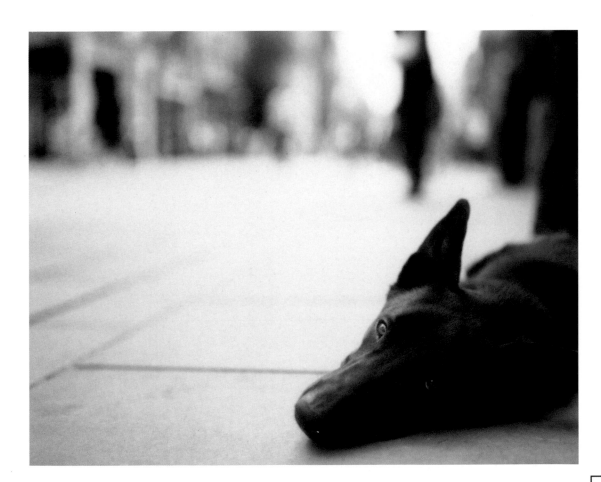

SOUTHWEST ENGLAND

gromit

The only dog that rivals Gromit when it comes to cool is Snoopy.

When Gromit isn't helping his best pal, Wallace, build things like rockets that take them to the moon for cheese, he's probably knitting or reading books like Dostoevsky's *Crime and Punishment* and Plato's *Republic*.

His favorite items are his alarm clock, his bone, and, of course, a framed photo of himself and Wallace.

poppy

Poppy is a thespian. At three years of age, she garnered the role of Toto in a stage production of *The Wizard of Oz*. Even though she gained critical acclaim for her "brilliant" performance, the roles have been few and far between during the six years since. As is the case for many female actors, it seems there just aren't a lot of strong parts for her to sink her teeth into.

Still, according to her "agent," she remains as starved for attention as ever.

Once a star, always a star.

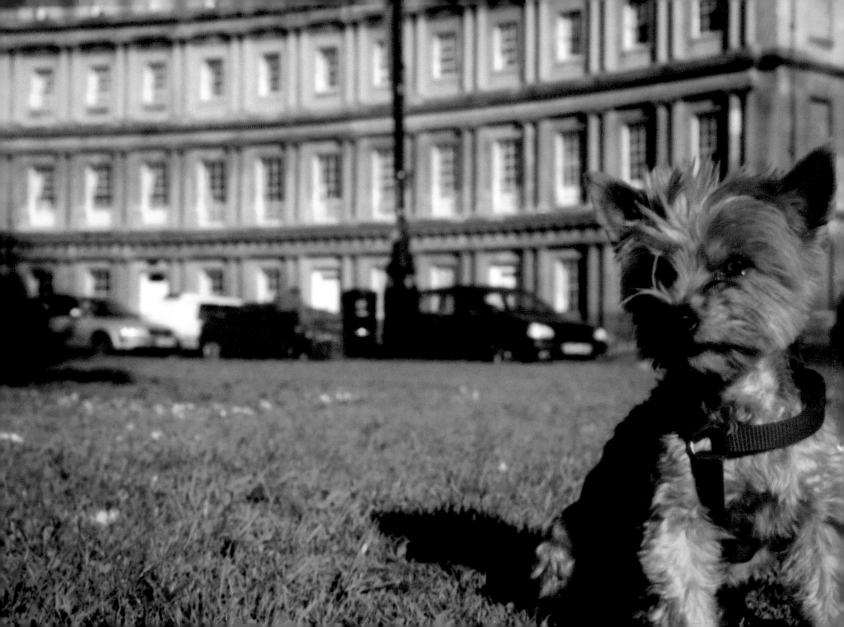

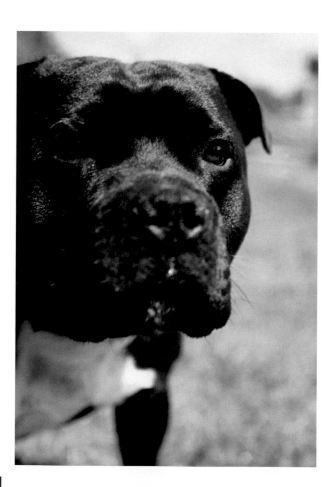

cracker

Cracker had won a number of dog shows before his head got too big. Literally. He was forced into early retirement because his noggin actually grew to be too large!

Humble at heart, Cracker would choose a nap on someone's lap—preferably on an oversize down pillow—over competing in a show any day.

PLYMOUTH

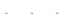

max

It's hard to believe, but Max takes on a miserable face when he's left indoors. This handsome pup lives for his "walkies."

His favorite destination is the Plymouth Hoe—the site where the *Mayflower* set sail way back in 1620. For Max, however, that historic locale, now a park, is where he'd prefer all his pilgrimages to end.

PENZANCE

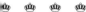

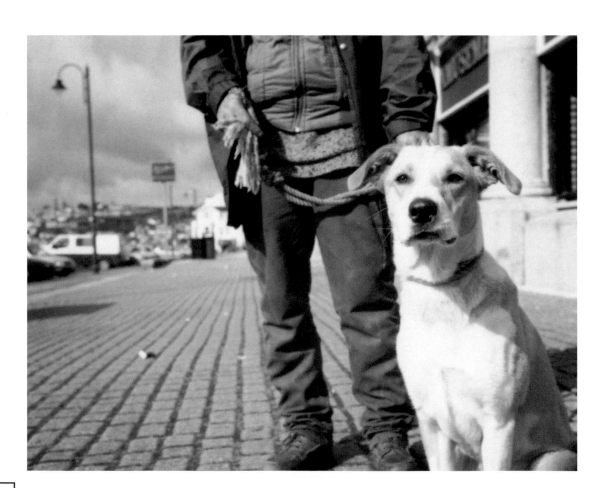

poppy

Poppy and her human live on the streets of Penzance. There are no real-life pirates to defend against, but Poppy does provide the added wall of defense that living on the streets sometimes requires.

As well, according to her human, she has much more success than he does raising funds for food.

"I eat a lot better ever since I got her," he states, "but Poppy always eats first."

prince

Hold on to your teacup, because this dog's tail never stops wagging. See for yourself when you pay a visit to England's westernmost point, Land's End. When you've reached this final destination, Prince will welcome you as if you were, well, royalty yourself.

Prince's off hours are spent scavenging for riches in the nearest compost heap.

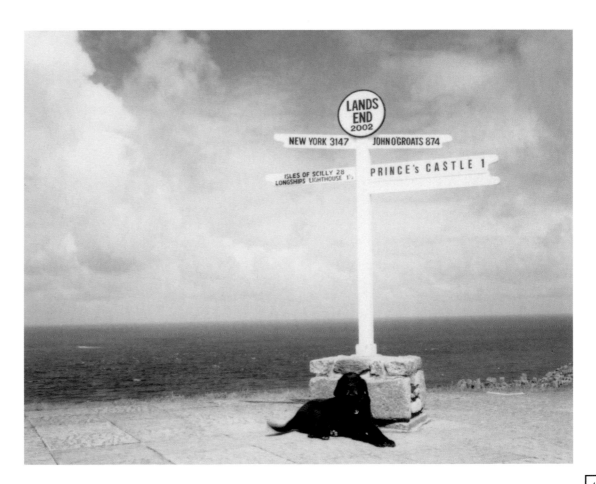

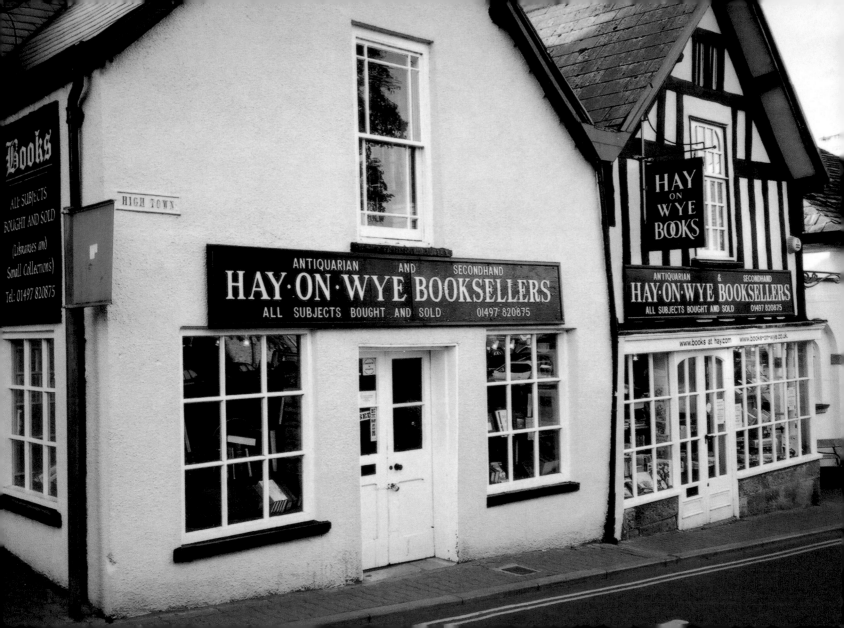

WALES

jasper

Jasper can't seem to differentiate between himself and his humans. He loves to sit on the sofa between them, he eats absolutely everything—including chilies—and he loves drinking red wine and beer. The only time he does seem to differentiate is when he's crawling through long grass on his belly.

But that's their loss.

ash

Ash works for the self-proclaimed King of Hay at the Hay Castle Bookshop in Hay-on-Wye—the world's first book town. One would think working for a king would be a bit nerve-wracking, but Ash seems to be quite comfortable with it. When he's not chewing the spine off one of the shop's millions of books, he's probably loading up on caffeine by scrounging teabags out of the rubbish bin. He's extremely elusive, too, which was a good thing for him after he peed on the red carpet underneath the king's throne.

Ash better hope this king is a little more patient than King Henry VIII, else he might just lose his head.

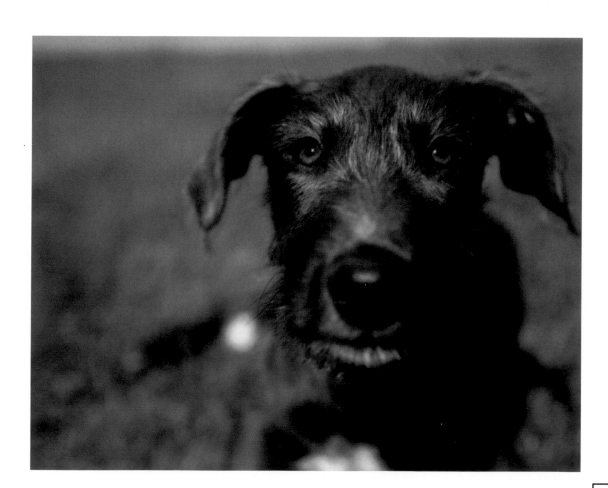

musky
& sally

Musky has sired eleven dogs, including Sally, his pride and joy. They pine for each other any time they are separated. In human circles, such affection might be considered beyond the boundaries of an acceptable father-daughter relationship. But in dog circles, it's pure love.

Their favorite times together are spent chasing squirrels on the historic grounds of Cardiff Castle.

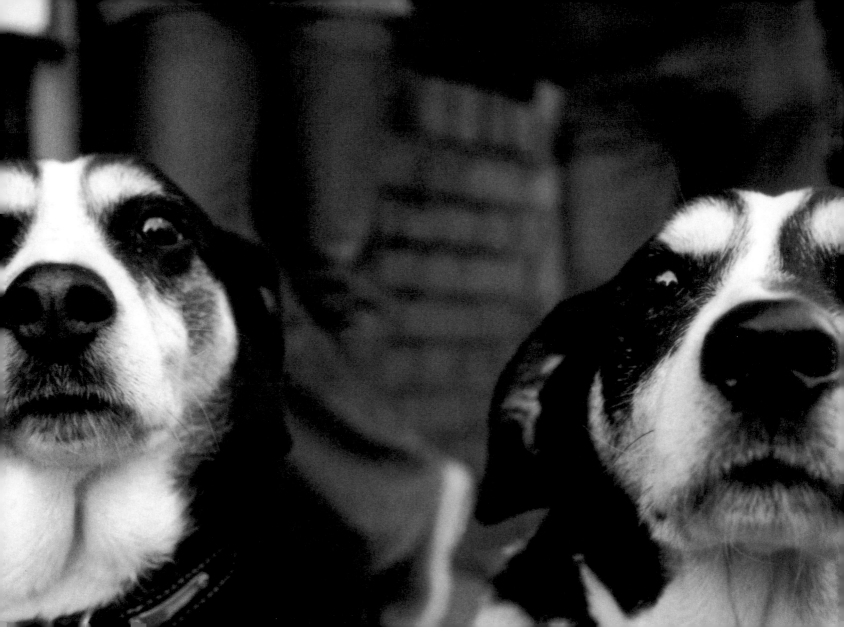

billie
& alfie

Billie was named after the late, great Billie Holiday, who once said, "If I don't have friends, then I ain't nothing."

Billie and Alfie concur wholeheartedly. They love racing along the shores of Swansea Bay together. Their favorite game is fetch. Alfie is about four times as fast as Billie, but he is such the gentleman that he allows her to get the stick every time.

Billie repays the kindness by pinching pastries from lunching workers when they're not looking.

Billie and Alfie definitely ain't nothing.

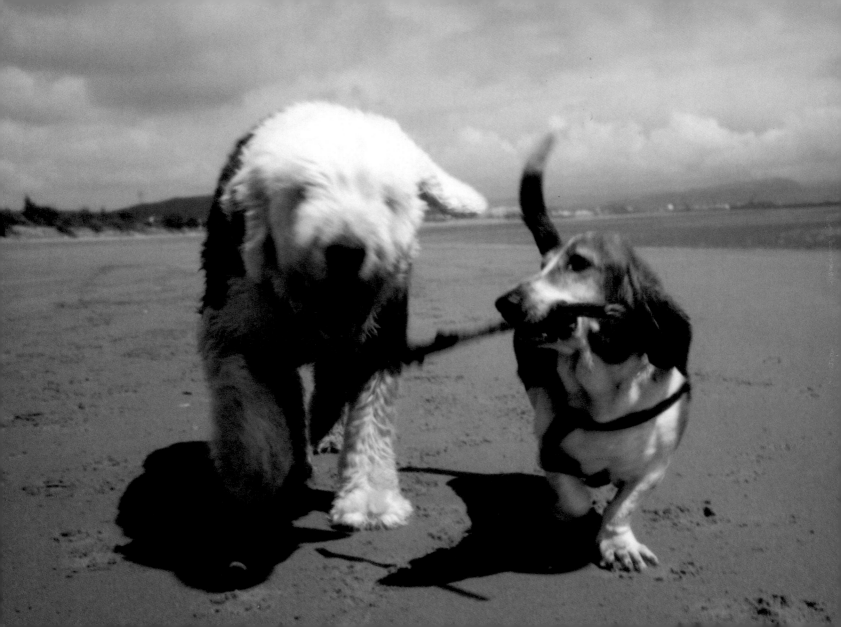

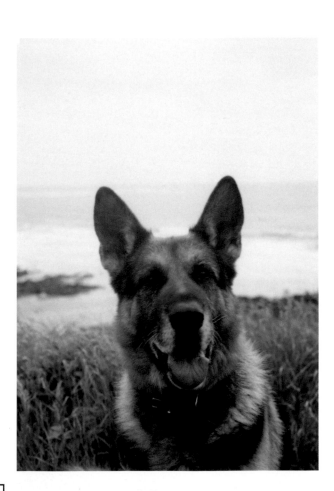

dacian

Dacian is known as the Sean Connery of the dog world.
He's that good-lookin'.

louis

Louis likes to play the role of the town bobby. He loves to wander the streets of Tenby to make sure everything is in order. Unfortunately for Louis, there is a strictly enforced leash law here, and he has been arrested six times himself.

When he's not in solitary or protecting his streets, he spends most of his days greeting customers at the Koolabah Café.

He may have a bad record, but he's a very good dog.

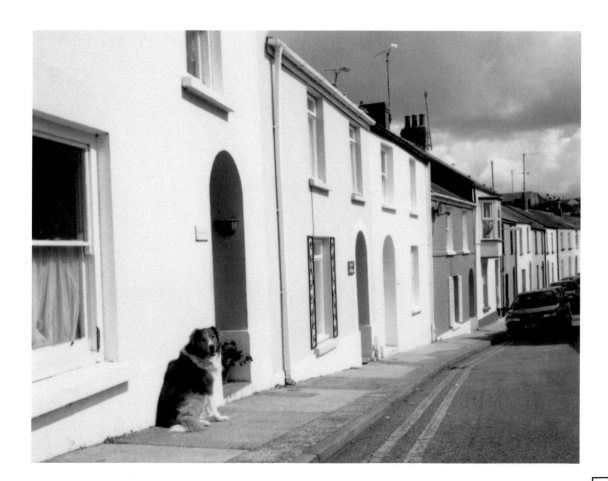

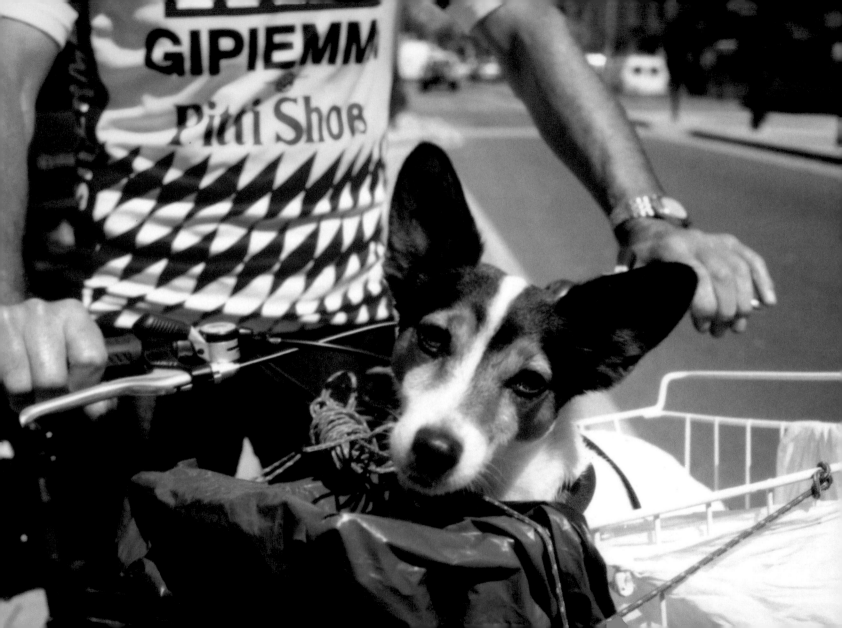

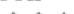

tina

Tina's home is the road. This photograph was snapped in Aberystwyth during a clockwise trip around the entire U.K. with her humans. Tina enjoys the easy life and loves her own space, especially when it's 4,000 miles in a basket on a bike. Impressively, her passport has been stamped in Ireland, Spain, and France.

When she's not traveling, she's most likely gone sailing. She even has her own life jacket, though one gets the sense she would have no trouble staying afloat without it.

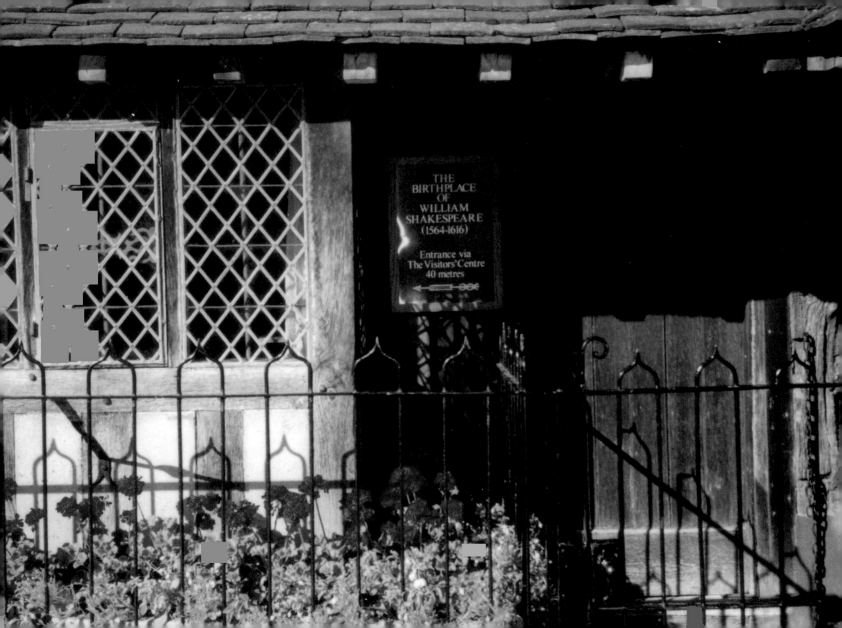

HEART OF ENGLAND

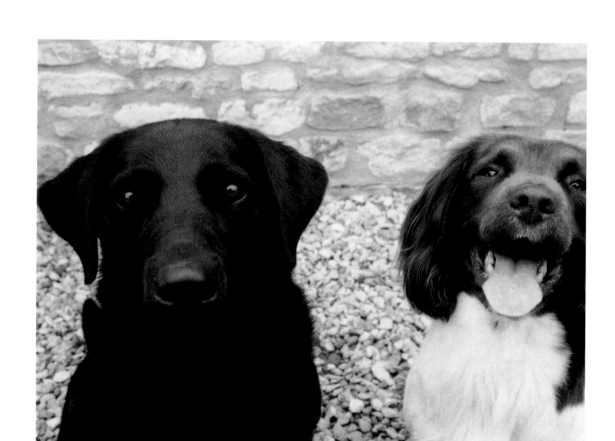

bertie
& oscar

Whether it's a quick trip to the market or a long ride in the Cotswolds, these two are standing at the ready. There's not a chance their humans can climb into their car without them. In fact, if the humans go anywhere near the garage, the dogs will jump into the family vehicle just in case. And if it turns out the humans have no plan to drive anywhere, Bertie and Oscar will sit and wait until it's time to go.

For these two, it's all about letting the good times roll.

puddin'

William Shakespeare once wrote:

Let Hercules himself do what he may,
The cat will mew and dog will have his day.

At fifteen years of age, Puddin'
has had many a day. He romps
the streets in the same town where
the Bard was born. Being a dog,
Puddin' doesn't seem to have
a great affinity for Shakespeare,
but it must figure that the
playwright would be impressed
with the dramatic tendencies of
Puddin', especially when a rabbit
or squirrel enters stage left.

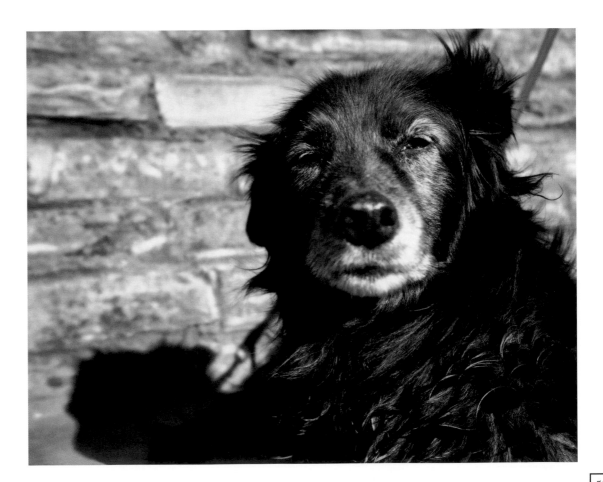

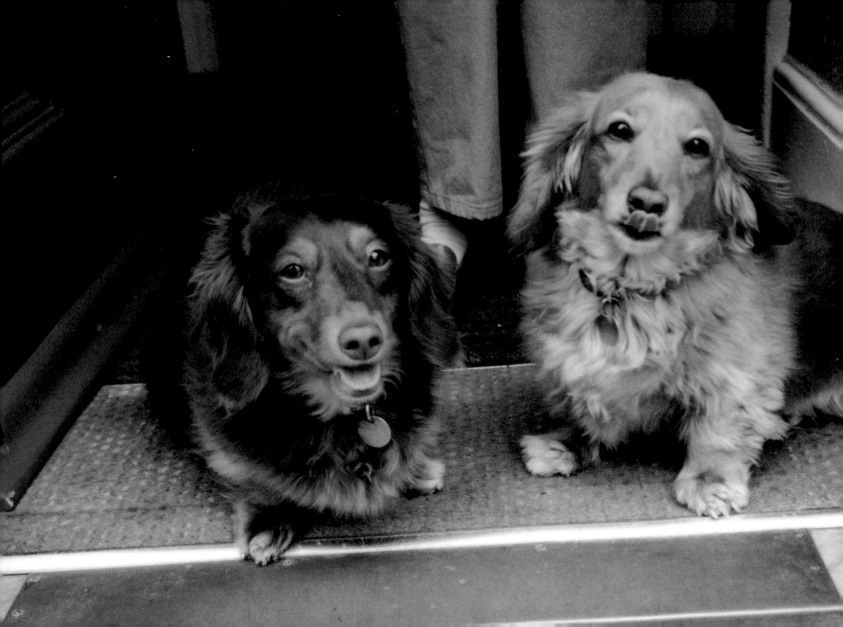

rosie & sophie

Rosie and Sophie are twins, but that's where the commonalities end. Rosie is out-going and loves everyone. Sophie is shy and protective. Their hard-of-hearing human owns and operates a bed-and-breakfast in the historic town of Chester. When visitors arrive and ring the bell, the dogs do their part by going absolutely mental, thus alerting the missus that a new guest has arrived.

Visitors are greeted warmly at the door but are not allowed to enter until Rosie gets her belly rubbed.

NORTH COUNTRY

dempsey

In Penny Lane there is a doggie with a collar on
Who likes to run for balls his human throws.
And all the people that come and go
Stop and say hello.

On the corner is a hydrant he lifts his leggie on
The little children like to scratch him on his back
And the postman never fears attack
In the pouring rain, it's not so strange.

Penny Lane is in his ears and in his eyes
There beneath the blue suburban skies,
He sits, and meanwhile back.

(Everyone!)

Penny Lane is in his ears and in his eyes
There beneath the blue suburban skies,
He sits, and meanwhile back.

Penny Lane!

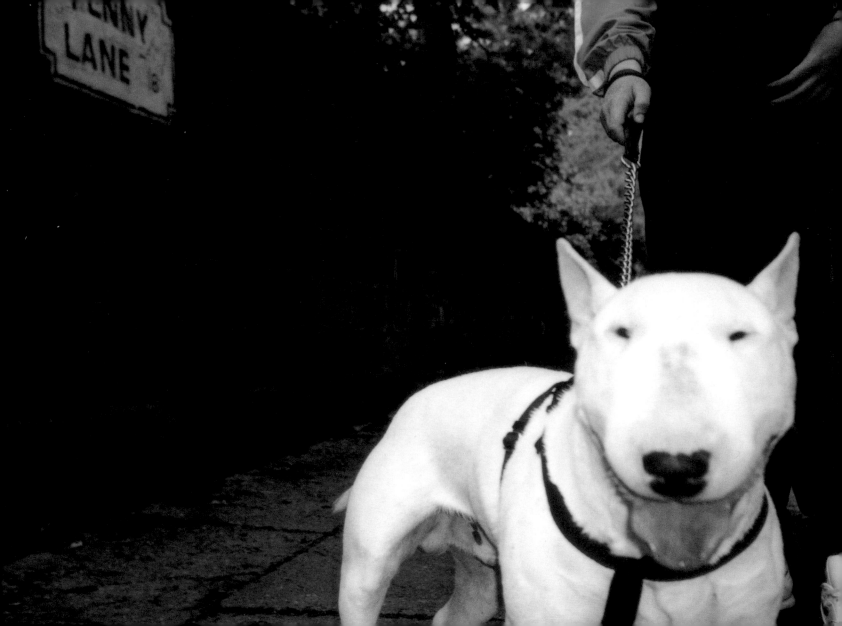

rabbits

Rabbits has an intimate relationship with cricket. He's simply batty about the sport. He's the number-one fan of the local Wellington Cricket Club, and he will sit on the boundary and root for his team all day long. Absolutely nothing can pull him away. Nothing. Well, okay, maybe one thing. He may love cricket, but he lusts after black Labs.

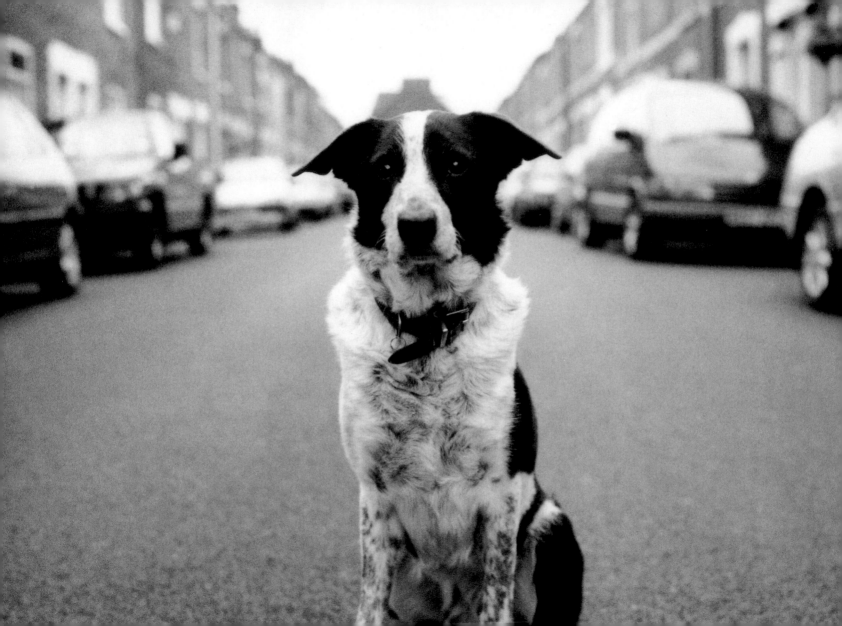

BRADFORD

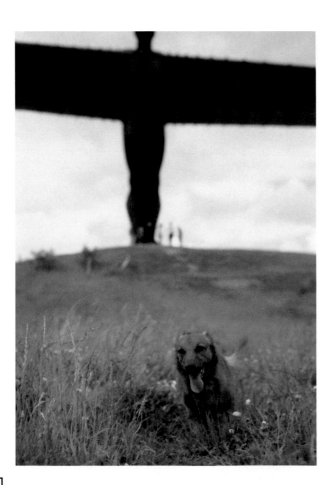

ben

Ben's got issues. He was abandoned at the age of eight weeks and has been a bit leery ever since. One major issue is the postman. He used to go mad every time the man came to the door. He would lose it to the point where he would actually shred the letters that were dropped. His humans finally had to place a mailbox outside their home in order to salvage the mail.

He also has a long-running grudge against standard poodles, for whatever reason. But the two things he dislikes most are men and cameras. Thankfully, this male photographer wasn't carrying a bag full of mail, and Ben let his guard down long enough to be captured in all his glory during a recent visit to the Angel of the North.

rusty

Rusty is a chocoholic with a passion for Smarties.

His other passion is water. Lucky for him, he lives in the heart of the Lake District. His favorite sport is sailing, although the first time he ever went out, he jumped overboard to swim with a school of ducks.

If you ever pay a visit to Keswick, be sure to keep a lookout for Rusty—one if by land, two if by lake.

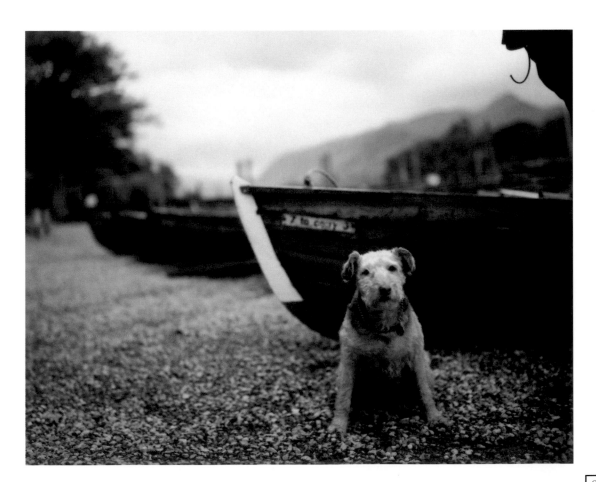

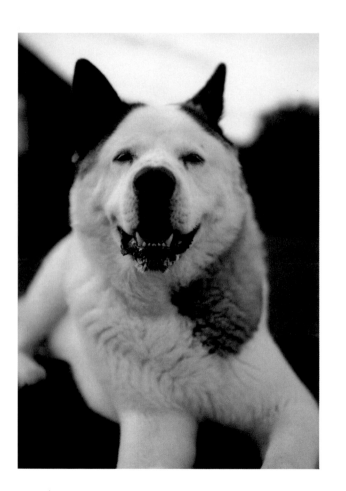

barney

Barney is a Japanese Akita, which may explain his fascination with wrestling. He likes to wrestle sumo-style with his human all day long—playfully, of course. He's a heavyweight, for sure, weighing in at over 12 stone, or 168 pounds!

He loves kids and accepts bear hugs from anybody willing to give one. He'll walk all day long, given the opportunity. When he overheats—as he is prone to do—he heads straight to the river for some cool-down time.

For Barney, it is always *inudoshi*—the year of the dog.

bertie

Bertie might as well be the official mascot of the legendary Manchester United football club. He is Man U through and through. His favorite color is red, and he never misses a game. After victories, he celebrates with his cronies over a pint of beer. He's no hooligan when it comes to the sport, but he will raise a ruckus if there is a vet in attendance. Bertie is quite the athlete himself. To get away from it all, he goes hiking in Scotland on any one of the 284 Munroes (as pictured here). A Munro is defined as any mountain with a peak at least three thousand feet high, and when one is successfully climbed, it is said to be "bagged." Bertie is hoping to bag each and every one before his dog days are done.

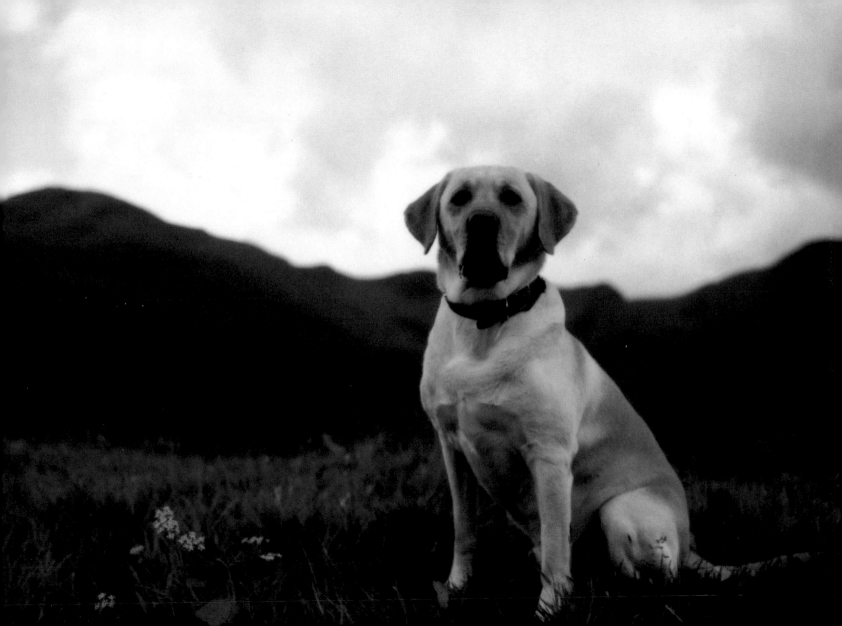

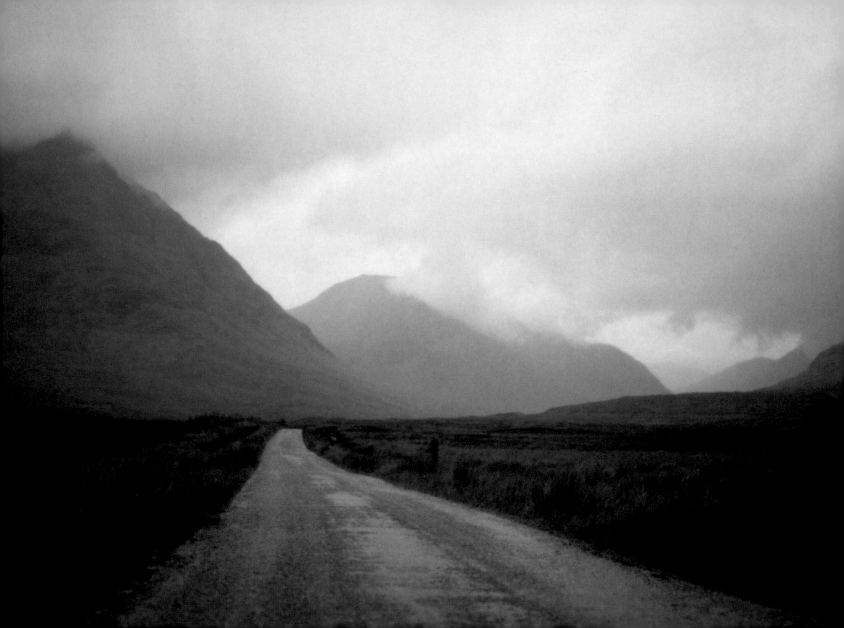

SCOTLAND

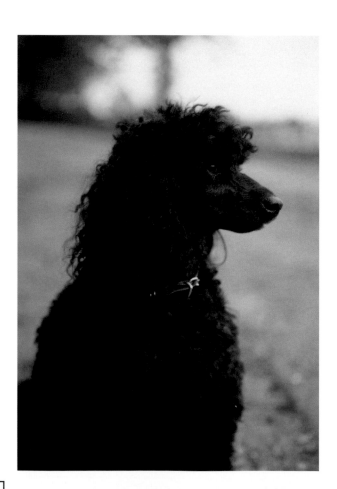

sioux

Sioux is the pride and joy of her humans. Her name, bestowed on her after one of them took a memorable trip to South Dakota, was inspired by the Sioux Indian tribe. She lives in the same town where famed poet Robert Burns lived and died, which is fitting, seeing that her love for humans is like a red, red rose that's newly sprung in June.

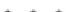

bobby

Bobby is the epitome of loyal. His master, John Gray, died in 1858 and was buried in the Greyfriars Kirk churchyard, Edinburgh's oldest cemetery. The morning after the burial, Bobby was found lying calmly on his master's tomb. The curator of the hallowed grounds immediately chased the unwelcome dog away, but Bobby kept coming back. Eventually, the curator realized he was not going to be able to keep this dog away, and he soon made an exception for Bobby. He even attempted to take Bobby in on cold, rainy nights, but had to let him out when Bobby's howling became unbearable. For the next fourteen years, until Bobby's death in 1872, the dog spent each night at his master's tomb. It is believed that the only reason Bobby ever left the churchyard at all was to uphold the tradition of he and his master's daily visit to the Traills Coffee House for lunch, continuing to return at one o'clock each day for his bone.

Bobby's loyalty was rewarded with a burial site of his own in the churchyard where he had once briefly been unwelcome. It's a safe bet he's resting in peace.

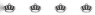

duke

Duke is the duke of North Berwick. Seriously. He is known and welcomed everywhere. And, like all royalty, he gets his share of special treatment. For instance, there's always a stool waiting for him at the local Quarterdeck Bar. He's not a drinker, but he will charm any barmaid out of a bag of crisps in all of two seconds.

He loves fetching golf balls for exercise, but his favorite activity is being bathed and brushed. He soaks it all up when he's becoming beautiful.

lubo

Lubo is a Border collie, and, like all Border collies, he loves to run about. Lucky for him, he lives in a flat directly across the street from Glasgow Green, one of the oldest and most historic parks in all of Scotland. Over the centuries, the Green has been used for public speaking, demonstrations, and even executions. Blimey! Nowadays, Lubo uses the entire park as his personal playground.

Of course, he's happy to share it, as he is a lover of all things. Well, almost. He tends to get his hackles up at the sight of bald men.

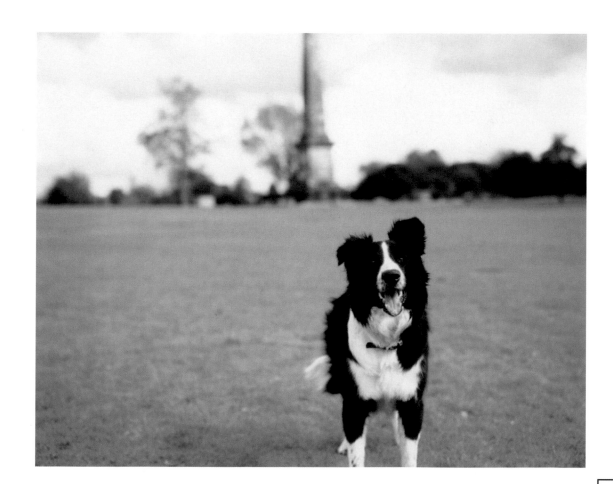

kassi

Kassi resides in the historic town of Stirling, the site of many great battles fought by the likes of Sir William Wallace and King Robert the Bruce, defenders of Scotland. Unlike Sir William and King Robert, however, Kassi's bark is much bigger than her bite. It seems she has gone soft while being spoiled rotten with love.

She is five years old and, by the time you read this, may very well have some little soldiers of her own.

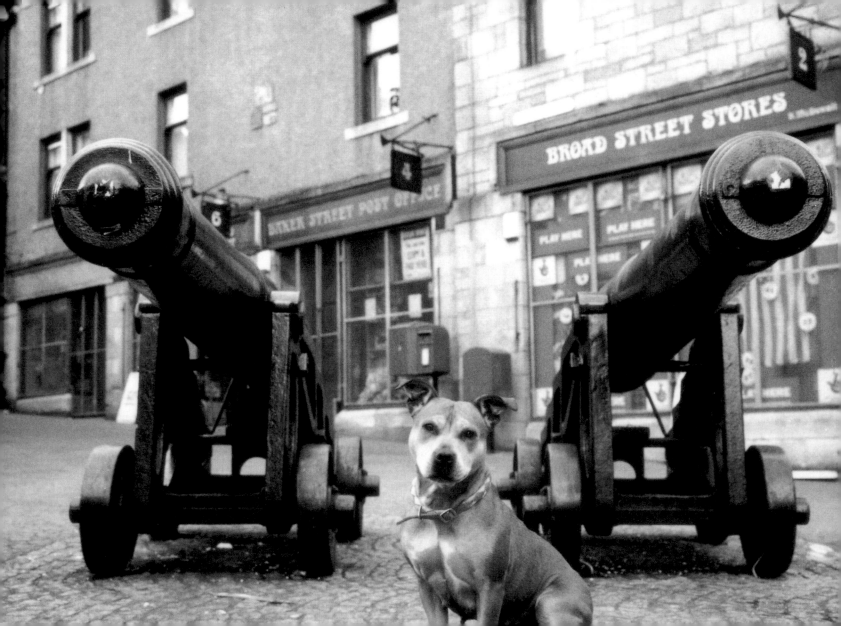

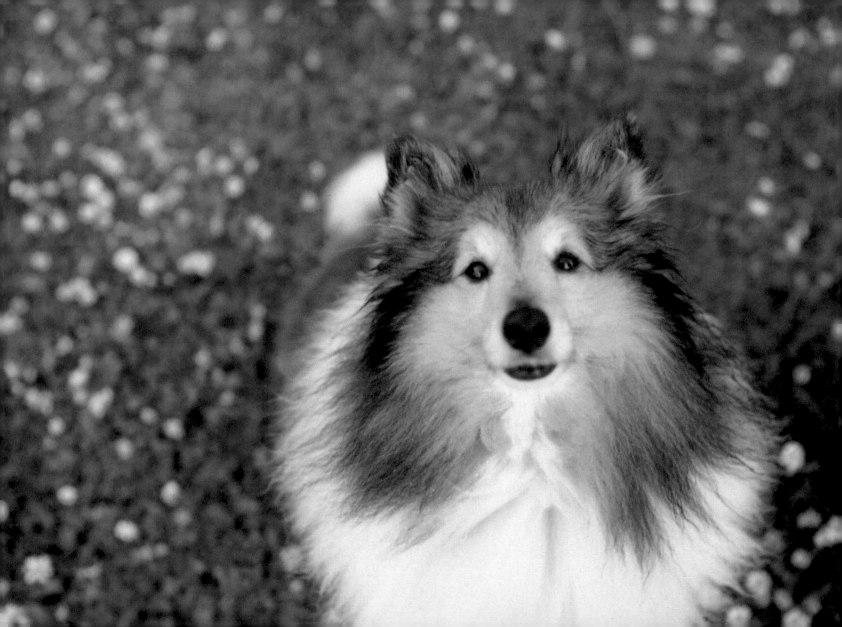

gellert

Gellert is a typical sheltie. He'll let you in, but he won't let you go.

Gellert is named after the most honorable of dogs. The story goes like this:

Once upon a time, there was a prince who had a favorite greyhound named Gellert. It is said Gellert was a big softie at home, but bold and relentless when it came to the hunt. One day, the prince called his many greyhounds before his castle to prepare for the day's chase. The dogs arrived, but there was no sign of Gellert. The prince became impatient and headed off without his best hunting dog, and it was no surprise when the prince returned home without success.

Gellert meekly greeted his angry master upon his return, and the man was startled to see blood dripping from Gellert's lips and teeth. Thinking of his infant son, who had been sleeping inside, the prince feared the worst. At once, he rushed into the castle to check on the child of whom Gellert was so fond. As the prince approached his child's quarters, he noticed blood on the floor leading to the room, and he swung the door open to find his son's crib overturned. There was no sign of the child, only of struggle. He quickly searched other rooms, but to no avail. The man assumed the worst and returned outside to where Gellert stood cowering.

The prince raised his sword in rage. Gellert took the blow, never diverting his eyes from his master's. As he let out a final howl, it was answered by a cry coming from inside the child's room. The prince rushed back in and cast the cradle aside, and underneath he found his unharmed heir. Next to him lay the slain wolf that had attempted to kill him. The man now realized why Gellert hadn't answered the summons earlier that day: He had been busy saving the life of his master'son.

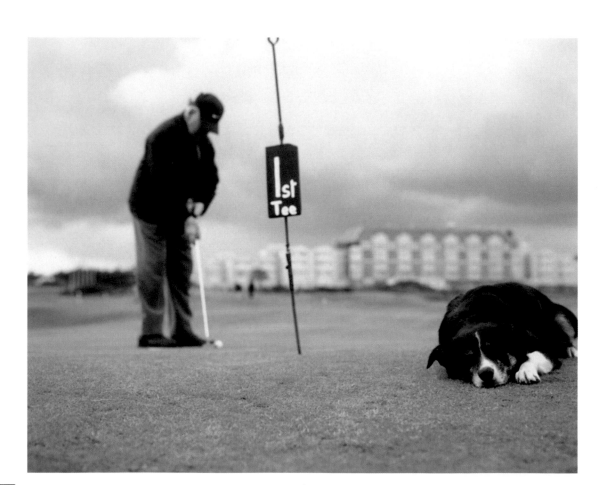

rex

Rex gives new meaning to the term "lying down on the job." He is the first assistant greenskeeper of the Ladies' Putting Club of St. Andrews, an eighteen-hole putting course also known as the Himalayas because of its rolling hills and difficult pin placements. When he's not sleeping, his main responsibility is chasing off the crows that like to peck holes in the ground.

In Rex's off hours, he is anything but lazy. Stick a mountain in front of him, and he will climb it all day long.

His native language is Welsh.

patch

At the time this photograph was taken, Patch was waiting for a new home. He got kicked out of his last one for talking too much. While between homes, he resides at Mrs. Murray's Home for Stray Dogs and Cats. The home was founded in 1889 by Susan Murray, and for more than one hundred years, there has never been a limit to the amount of time an animal can stay. Of course, Patch is hoping his sojourn will be brief. He's dying to practice his Queen's English on someone.

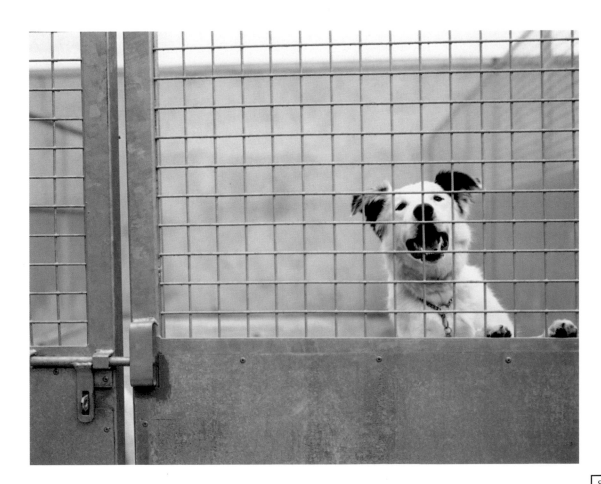

INVERNESS

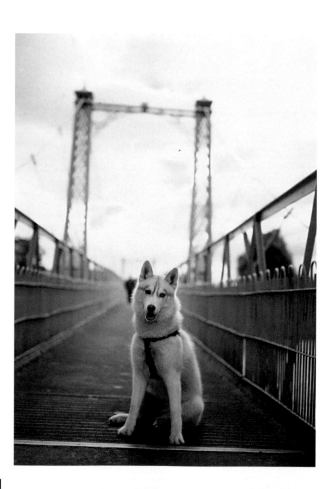

misha

Misha is a striking young Siberian husky who loves playing in the snow. Good thing, too, because she is a sled dog in training. She lives in the heart of the Scottish Highlands, where she has a host of towering mountains on which to practice finding her stride.

Go dog, go.

sally

If her nose isn't to the ground, it's probably high in the air. Sally is the queen of Ullapool. Sally is a West Highland terrier, and the long history of her breed is an interesting one. Originally, the Westie coat colors ranged from black to red to cream to white. Legend has it, however, that Colonel Edward Donald Malcolm of Argyllshire, Scotland, was out hunting with one of his red Westies when his dog emerged from the woods and was mistaken for a fox and shot on the spot. Crushed, the colonel made the immediate executive decision to breed only white Westies so that the same mistake would not be made again.

Sally can live with that.

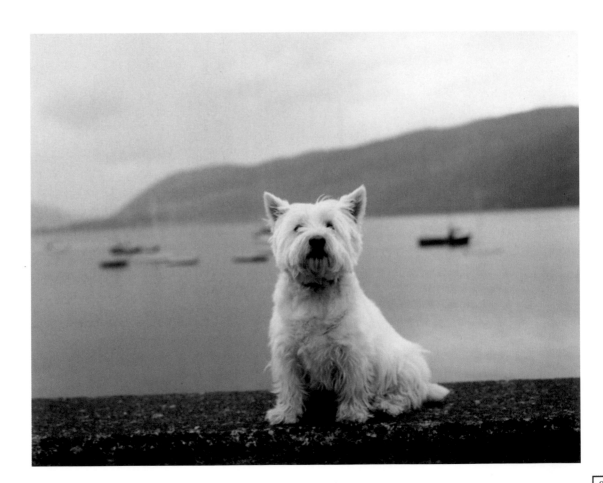

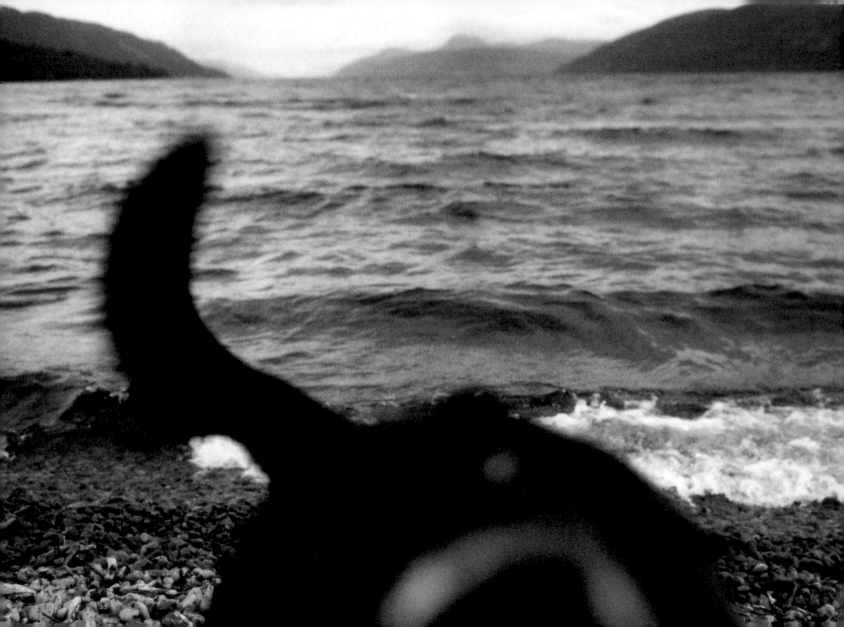

daisy

I'm often asked how I find my dogs. At first I didn't think much about it, but, as time has gone on, I've come to believe my destinations have been predetermined. Take Daisy, for instance. Was our meeting chance? Or was it choreographed?

I went one evening to the head of Loch Ness with the simple intention of doing a little landscape photography. Admittedly, I was hoping I would be the one to capture the definitive shot of elusive Nessie, the Loch Ness Monster. The sky was filled with billowing dark clouds, and the loch was covered in whitecaps as far as the eye could see. Equipped with my 3000-speed black-and-white Polaroid film, I still had plenty of light—in fact, I couldn't have asked for better elements for the shot I was after.

I snapped a few photographs and contemplated the land around me. It occurred to me that of all God's creation here on Earth, Scotland must be considered his masterpiece. Monet, Rembrandt, Picasso—they've all got one. So God must have one too, right? Why not Scotland? I mean, everywhere you turn, beauty is in front of you. Heck, if I were a monster this is where *I'd* hide.

As I was taking it all in, I realized it was the perfect setting for a portrait, if only there were a dog around. At this particular moment, it felt like I had a better chance of finding Nessie. Then, seemingly out of nowhere, this black dog appeared and promptly wagged her way up to my lens to the point of actually touching it with her nose. I was so shocked, I almost forgot to take the picture. I did, however, as you can see. After a few more shots, though, she disappeared as instantly as she had arrived. I then looked at my watch and realized I needed to get back to town to find a place to sleep.

>>>

I drove from the water's edge back to a little two-lane highway and saw the black dog again, standing smack in the middle of the road about a quarter of a mile in the opposite direction from Inverness, as if inviting me to follow her. Taking a left toward town would have been the sensible thing to do. I took a right. The dog led me up the road to a driveway, where I pulled up and was greeted by an older gentleman. I told him about my book and asked whether he would mind if I included his dog. In the thickest of brogues, he replied, "Oh, no, not at all, but would ya like to come in for some tea?"

It was 10 p.m., and I knew accepting meant pushing my luck finding accommodation. But before I knew it, I found myself served tea and cake, Daisy sleeping at my feet, hearing tales of Nessie. Then the gentleman and his wife offered me the upstairs bedroom—it was as though I'd died and gone to heaven.

Just an hour earlier I had been wondering where I was going to sleep. But, once again, as happens often in my travels, I found that when you follow your heart and your dreams, the world conspires to help you. I know this might sound hokey, but how would you know if you're not following your heart in the first place?

As John Steinbeck wrote in *Travels With Charley*, "We do not take a trip, a trip takes us." That pretty much sums up how I find my dogs. Daisy was an angel. I have no idea who sent her, but she came, and I followed. Her parents were angels as well: They gave me food, shelter, and directions. In fact, it was they who pointed me to the Isle of Skye, where I met Sophie, the dog pictured on page 92.

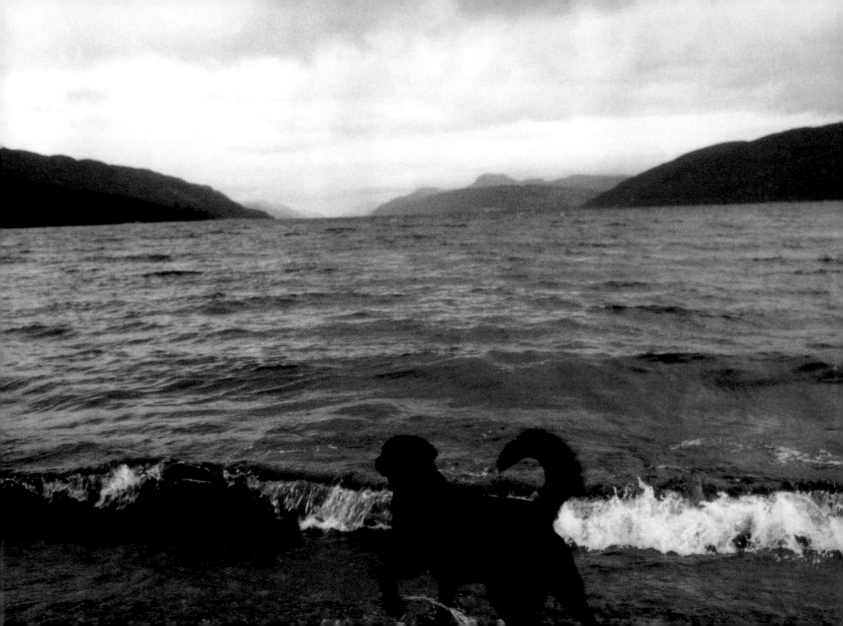

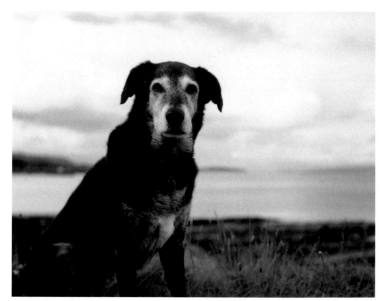

sophie

Sophie was named after the ancient goddess of wisdom.

She is definitely an old soul—even older, now that she is sixteen years of age! She passes her wisdom on to anyone who will listen, though her favorite audience has always been small children carrying food.

ACKNOWLEDGMENTS

Cheers to me mum. Thank you for having me. And for everything after. I miss you.

Cheers to me duddy. Thank you for showing me how to live *the high life*.

Cheers to me brothers and sisters, my very own royal family. The best.

Cheers to me budding photographer, Sam Cole. The road will always lead back to you.

Cheers to Alice. Speaking of roads, someone sang about the long and winding. They never mentioned all those bumps! Still, the ride's been so worth it.

Cheers to all my friends and extended family. I can't try to name you all, because I will screw up and leave someone out. You are all in my heart, and I thank all of you for letting me into yours.

Cheers to Seamus—my favorite wingman. I missed you on this one. Maverick just ain't the same without Goose. (R.I.P., Bimbo.)

Cheers to Otis, my favorite wingdog. I'm so sorry I had to leave you and your ball behind on this one. We really need to do something about that six-month quarantine law.

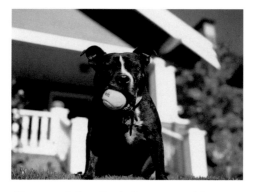

Cheers to John, Paul, George, and Ringo. You were right. All you need is love.

Cheers to the other artists and bands that made up the soundtrack of my journey: Billy Bragg and Wilco, Radiohead, Travis, Oasis, Coldplay, Badly Drawn Boy, Elton John, Rod Stewart, and, of course, the Rolling Stones. There's just something so cool about feeling like you can make it halfway across England listening to "Midnight Rambler."

Cheers to the bloke who came up with the iPod, which must be considered one of the world's greatest inventions.

Cheers to Avis for the rental car. Thanks for trusting me to drive a stick on the wrong side of the car on the wrong side of the road while reading a map and trying to figure out road signs while negotiating the round-abouts with cars zipping every which way around me.

Cheers to the amazing Meyer family for providing me bed and bath during my time in London. How lucky can a guy be? I'm serious about the adoption papers. Please. Please adopt me.

Cheers to Winston Churchill for preserving your country and, most likely, humanity. Wish you were still here.

Cheers to Elliot Erwitt, William Eggleston, John Steinbeck, Errol Morris, Kofi Annan, Jimmy Carter, Mohandas Gandhi, Muhammad Ali, and David Letterman. A few of my heroes.

Cheers to Dan Wieden and David Kennedy. Heroes I can actually see and touch. I can't thank you two enough.

Cheers to the following people I work with at Wieden + Kennedy: Patty, Brian, Shannon, Tieneke, Lisa J., Jen F., Julie G., Andy, Katie, Karen, Colleen, Tiffany, Brie, Thomas, Terry, Jason, Chris V., Allison B., Jen P., Tim, Tara, Nolan, Anne, Ademar, Dana, Fran, Peter W., Barb, Shari, Liz, Benny, Bill D., and, last but definitely not least, Jeff W. Many of you pointed me in one direction or another. Others just helped. Thank you. Ooh, I almost forgot. Susan, I owe you big time!

Cheers to Tanja and Heather two books late, to Michael K. for the push, to Jennifer and Danielle for the sandwich, to Ken for the sweet pad in St. Andrews, to Monty for the stars of North Berwick, to Jonathan and Slip for all the insider tips, to Bedonna for your words and wisdom, to Michele and Peter for the super deal and the super cover, and to Ann and Frank for having the coolest daughter in the world.

Cheers to Shoshanna for all the attention and helpful suggestions, and to Jack Jensen for being such a lover of all things dog. Long live Chronicle!

Cheers to Edwin Land for my wonderful camera and to the Polaroid Corporation for existing long before the world ever went digital. Bravo.

Cheers to the lovely Alicia Kuna for putting me on a lead and showing me the way. I would have been a complete stray without you. Nutcracking author photo! (Confession: She took the rad photo on page 16.)

Cheers to Nick Park and Aardman for Gromit.

Cheers to the amazing people I met along my way. I'm constantly floored by the willingness of people to let a complete stranger into their world. Thanks for all the tea.

Cheers to every dog I met. Each was an unfailing conduit into the lives of their humans. More important, each was a conduit into the world of virtue, loyalty, patience, and overall goodness.

And, finally, one last cheer, to the otherworldly Hawthorne Hunt. If you were here, I know you would demand a picture of your cat in the back. This last one is for you.

♛ ♛ ♛

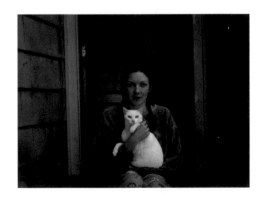

95

AFTERWORD

Dog holds his noble station on infamous merits, reliably true.
Us humans plod on with our math, the figuring out of this way
from that.

It's when we take up the riches of friendship with Man's Best
That the shortcut turns up and the Moment we chase becomes
The one that we're in.

So does a photograph foist us there. Its story springs from the
moment. An image insists notice for all any second might hold,
Yet story bounds onward to defy a shutter's constraint.

A dog will look into your eyes and you will feel known in the way
You know yourself, or anything True. A photograph will invite you
into its event and your impressions propel story without language.
It's this sort of Quiet that guides a life to confirm what is right
(or not), what is honest, which way to go.

These Quiet Things Known aligned to launch Selis on a journey
begun of challenge, then expanded in distance and deepened in
purpose to reveal the true requisite of his craft, Trust.

Dogs connect with Selis. Each one vogues dignity into his lens.
A calm wisdom glows from the faces of the dogs that romp into Jeff
Selis's path. And the more dogs he meets, the more their calm wisdom
tells him which way to go.

This third collection of regal beings carried Selis across the drink,
To the motherland of the world's most dignified and most scrappy
Breeds.

Cheers to the Citizenry of the great U.K., who opened their homes,
Hearts, and stories to Selis's discovery. However far afield his Polaroid
Land Camera throws him, Selis fetches again,
That quiet uniting thought that each journey holds a happiness
Like that known between dog and Us.

Tails wag joy by design and remind us that what's best
Is worth chasing. Even round and round.

Jolly good, then.

Dog Save the Queen.

And the bloody lot of us, too.